Landscapes in Oils

To James, Joseph and Jonathan, whose enthusiasm keeps me young at heart.

MICHAEL
SANDERS
2001

Landscapes
in Oils

MICHAEL SANDERS

SEARCH PRESS

First published in Great Britain 2003

Search Press Limited
Wellwood, North Farm Road,
Tunbridge Wells, Kent TN2 3DR

Reprinted 2006, 2007

ISBN 10: 085532 850 9
ISBN 13: 978 085532 850 4

The Publishers and author can accept no responsibility for any consequences arising from the information, advice or instructions given in this publication.

The Publishers would like to thank Winsor & Newton for supplying many of the materials used in this book.

Suppliers

If you have difficulty in obtaining any of the materials or equipment mentioned in this book, then please visit the Search Press website for details of suppliers: www.searchpress.com

Alternatively, you can write to the Publishers at the address above, for a current list of stockists, including firms who operate a mail-order service, or you can write to Winsor & Newton requesting a list of distributors.

Winsor & Newton, UK Marketing
Whitefriars Avenue, Harrow, Middlesex, HA3 5RH

Publishers' notes

All the step-by-step photographs in this book feature the author, Michael Sanders, demonstrating his oil painting techniques. No models have been used.

There is a reference to animal-hair brushes in this book. It is the publishers' custom to recommend synthetic materials as substitutes for animal products whenever possible. There are a large number of brushes made from synthetic materials available, and these are just as satisfactory as those made from animal fibres.

Printed in Malaysia

I would like to thank Chandy Rodgers for encouraging me to write for SAA Paint magazine, which got me started; John, Lotti, Juan, Rachel and Roz at Search Press for their enthusiasm, expertise and advice; and all my kind students, SAA members, and fellow artists, from whom I continue to learn. Last but not least, thanks to Gwynneth for inspiration and support!

Front cover
Cornfield Poppies
Size: 585 x 450mm (23 x 19in)

This is a nice, warm, vibrant image. The subtle colour change in the cornfield denotes a pathway which leads the viewer's eye towards the figures, the church and the village. The trees, though dark, contain plenty of interesting touches of colour.

Page 1
St Mellion through the Trees
Size: 200 x 255mm (7¾ x 10in)

I was attracted to this scene by the linear nature of the composition; ploughed furrows in the foreground leading the eye almost out of the painting, then back in.

The distance and middle ground, although broken by the tree trunks, maintain cohesion because of the lines of the road and hedges.

Page 2/3
Dartmoor Farmstead
Size: 300 x 240mm (11¾ x 9½in)

A gentle, misty, moorland scene, where low cloud obscures the tops of the hills. I wanted to capture the quiet subdued atmosphere, and the feeling of isolation from the outside world, that mist on Dartmoor evokes. So, after making a series of sketches (in case the mood changed too much), I completed the painting quickly in one go.

I used a very limited palette of ultramarine (green shade), Winsor lemon, burnt sienna and titanium white on a pre-primed orange-brown board. The distant hill was painted in pale blue-grey, then I used a fan brush to drag the sky colour across it, wiping the brush carefully between each stroke.

Opposite
Kit Hill
Size: 255 x 200mm (10 x 7¾in)

Kit Hill is a local landmark and the highest point for several miles. I wanted to create the feeling of steepness which I achieved by the shape of fields; not too foreshortened. There is a satisfying sweep to the road as it curves in from the left.

Contents

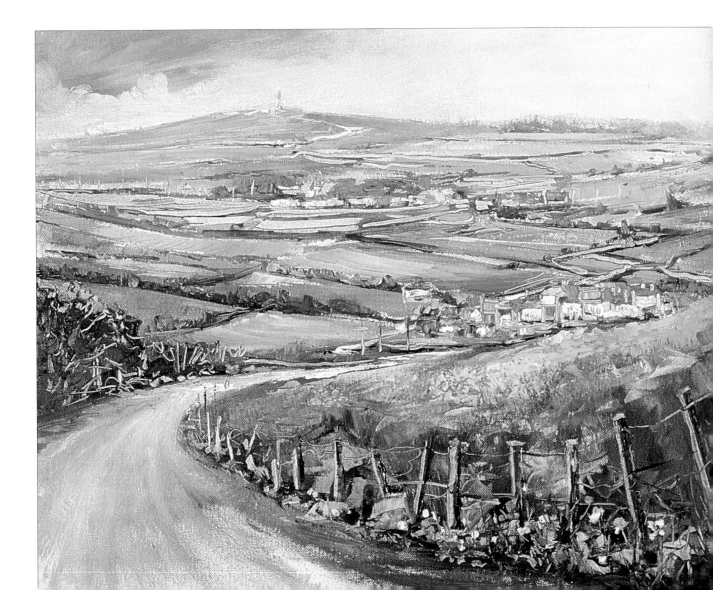

Introduction

Oil paint is one of the most expressive and versatile of mediums. With its smooth, buttery consistency you can create blended areas of colour with soft edges, heavily textural ridges of paint or pin-sharp highlights of brightness.

For centuries, oils have been the first choice of artists wishing to capture the myriad moods and colours of the great outdoors. Landscapes are a timeless source of inspiration. Each season brings different colours and textures, and the sky illuminates the scenes with different types of light that create a marvellous variety of atmospheres.

As with any subject, the way to begin painting a landscape is to learn to really 'see' it, and you should get into the habit of studying the world around you every time you leave home. Compare tones in the distance with those up close, and notice how distant objects appear pale, hazy and bluish. Look at the sky and see how many colours there are, and note how water reflects those colours. Watch cloud formations, and observe how they catch the sun and cast shadows. Compare the colours at the top of a tree with those in the shade at the bottom. It does not matter if you have never painted before – looking, seeing and comparing colours and tones will get you well on your way.

In this book, I will take you, stage by stage, through the most important landscape painting techniques, as I build images up, colour by colour and stroke by stroke. Follow me through the demonstrations, then, using your new-found skills you will be ready to create paintings of your own – works of art that you can be proud of.

As you paint, you will feel attracted towards particular colours and techniques, or your creativity will lead you to try different techniques and maybe invent some of your own! Be bold, do not be afraid of colour or texture, do not worry about the occasional mistake and, above all, have fun!

Opposite
Working the Land
Size: 300 x 400mm (11¾ x 15¾in)
A lot of the work on small market gardens in the part of Cornwall where I live is still carried out by hand because of the steeply sloping terrain. There is an air of gentle dereliction about this image; the buildings show signs of neglect while the old man carefully tills the soil. I chose the colours to impart a warm nostalgic atmosphere. The washing hanging out to dry lends a mood of domesticity.

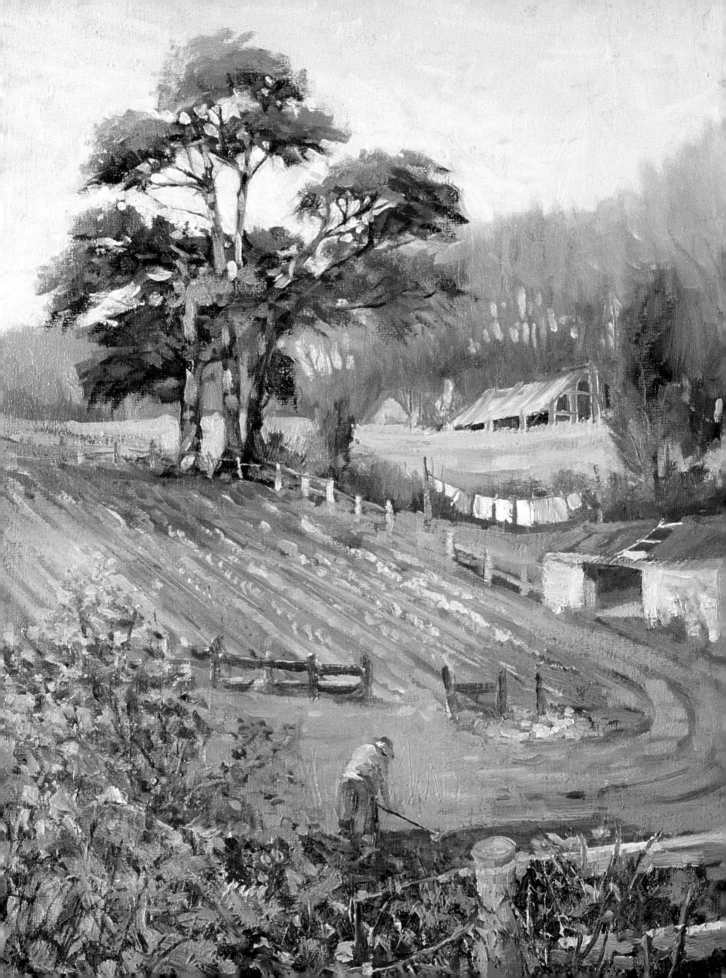

Materials

There is a vast array of colours, mediums and solvents available for oil painters, and for the beginner this wide range of products can seem quite confusing. But do not worry; to get started, all you need is a small selection of brushes, a painting knife or two, less than a dozen colours, a bottle of medium and some white spirit.

Paints

One simple rule when buying paint is to get the best you can afford. Artists' quality oils will usually state on the label that they are 'Artists' Oil Paint'. If you intend to paint bright colours such as flowers, you will get better results from these paints as they generally contain purer and more intense pigments than students' colours.

I restrict the number of colours I use and this is termed a limited palette. I have selected these colours over several years and find I can paint most subjects with them. Using a limited palette simplifies the task of colour mixing, as you can learn the combinations with a little practice (and remember how you did them!).

My palette has a warm and cool version of the three primary colours (red, blue and yellow), three landscape colours and a white (buy a large tube of white because with oil paints, white is added to lighten a colour). My reds are cadmium red (warm) and permanent rose (cool), my blues are ultramarine (green shade) (warm) and phthalo blue (cool), and my yellows are cadmium yellow deep (warm), and Winsor lemon (cool). My landscape colours are permanent sap green, Naples yellow and burnt sienna (all warm), and my white is the coolish titanium white.

Cadmium red Permanent rose Cadmium yellow deep Winsor lemon Ultramarine (green shade) Phthalo blue Burnt sienna Naples yellow Permanent sap green Titanium white

Palettes

Any flat, non-absorbent surface can be used for mixing paints. Some artists use plastic or metal trays – even glass. But, for ease and comfort, nothing feels better than a traditional wooden artist's palette. The neutral tone of the wood takes on an interesting patina with use, and it is easy to judge colour mixing on a mid-toned background. I have several wooden palettes. My favourite is hinged in the middle – it can be folded up with the paint still on it, and I can carry it home and finish the painting later without needing fresh paint. You may find disposable paper palettes useful. The paper is similar to greaseproof paper and comes as a palette-shaped pad. The used sheets can be torn off and thrown away.

Complete the palette with a dipper, a shallow metal pot that fits on to the edge to hold thinners or linseed oil. I have a double dipper on each of mine.

Solvents and mediums

There is a wide range of preparations on the market but, as with oil paints, it is best to restrict yourself to a few and get to understand them.

Oils can be thinned with solvents or mediums: solvents reduce the oil content, making the paint more watery and faster drying; mediums make the paint more workable while retaining its oil content.

Turpentine is the traditional solvent for oils, but it is quite expensive and has a strong odour. The less expensive white spirit can be used to clean brushes and, in the early stages of a painting, to thin paint. Nowadays, some very good low-odour thinners are available for those of you who find the smell of turpentine and white spirit offensive.

The traditional medium for oils is linseed oil which comes in a variety of thicknesses with 'stand oil' being the thickest. It imparts a gloss to your work, but makes the paint slow drying. If you want to build a painting layer upon dry layer, you will need an oily medium to thin subsequent layers, especially if you allow a half finished painting to dry for about a week. Using paint thinned with white spirit or turpentine on top of dry oil paint could result in poor adhesion. Alternatively, you could simply use them undiluted, straight from the tube.

For a speedier drying time, Liquin (an alkyd medium) is very good for thinning paints, and enables you to work wet on dry without waiting too long between stages – about two days.

All the step-by-step demonstrations in this book and most of my other paintings are painted wet on wet, so I rarely use mediums (except refined linseed oil or Liquin, if I am working on a dry painting).

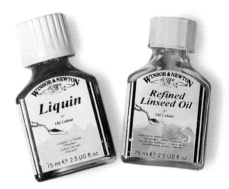

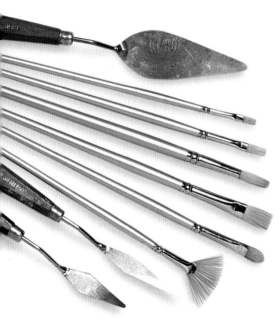

Brushes and knives

The traditional oil painting brush is long-handled and made of hog bristle. These days, there are some excellent synthetic equivalents and, personally, I prefer them. It is best to get a selection; you will gradually develop favourites that suit your style.

There are three basic brush shapes: flat, round and filbert with either a regular or long length of bristle. The flat brush is chisel shaped, the round is tapered almost to a point and the filbert starts like a flat then gently tapers towards the tip. A fan brush is a useful addition for gently blending one colour into another.

Brush sizes are usually denoted by numerals, the larger the number, the bigger the brush. The size you choose will depend upon the size of board or canvas you feel comfortable with. It is best to have at least a couple of large brushes (bigger than you think you will need) for covering large areas. I think it is good to paint with large brushes anyway – it stops you from becoming fiddly. I restrict the use of very small brushes to a few highlights, applied when finishing a painting.

Knives also have many uses in oil painting: for mixing paint; scraping off the occasional error; applying paint, both with the edge or the flat of the knife; and using the tip of the knife to scratch out fine lines in wet paint. I own several knives, most with leaf-shaped blades. Knives with bent handles, known as painting knives, are most useful.

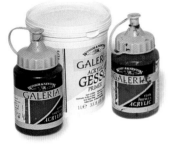

Surfaces

Almost any non-shiny surface will take oil paint. Historically, oils were painted on wooden panels which were joined together, sanded and primed. Then canvas, stretched tight on wooden frames, became available. Nowadays, we also have a wide selection of hardboards, cardboards and fibreboards to choose from.

Whatever surface you choose, it must be prepared well. I paint all my surfaces, even ready-to-use canvas and board, with gesso, a thick acrylic primer. I usually mix the primer with an acrylic paint to make a tinted ground. I find this better to work on than a glaring white surface, and the tint makes it easier to adjust tones and colours.

Easels

Wherever you work, in or out of doors, it is important to step back regularly to see how the painting is progressing. The bigger the canvas, the further away you need to be to get an overview of it. For this reason, an easel of some sort is essential. The painting board will be close to vertical, so ensure that the easel is sturdy when in this position.

I prefer to work standing, even in the studio, but, whether standing or seated, the main consideration must be comfort, so set your painting at a height that does not cause cramp or aches and pains in your back and shoulders. A simple, lightweight, sketching easel is fine if you intend working outdoors and weight is a factor; you can hang a bag of stones on it to stop it moving about in the wind. If you never want to paint outside, then a table or box easel may be the thing, but make sure its height is adjustable so it does not cause you to stoop.

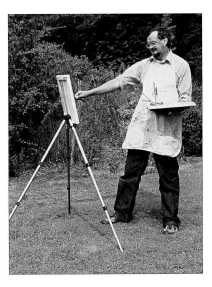

Other equipment

There are a few other items that make life easier, and I always like to have these with me when I paint. The most important, even before you open a tube of paint, is a plentiful supply of paper towels or clean, lint-free rags. You will need at least two screw-top jars for clean and dirty thinners, and some pens, pencils and sketch pads for thumbnail sketches. I also use sponges and scraps of paper and card to add texture to my work, and you may find these useful too.

Then, at the end of a painting session, brushes have to be cleaned; I clean mine in white spirit first, then with brush soap. Use a back-and-forth painting action on the soap until no further colour comes out, then rinse in water. Apply a little clean soap to the clean brush and allow to dry; this will help the brush keep its shape.

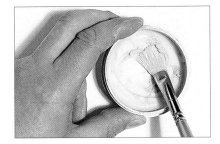

Understanding colour

Colour is a subject I am frequently asked about. How do you avoid colours that clash or look muddy? How do you create depth in a painting? It is true that, no matter how interesting, or how well-drawn a composition is, poor or indifferent colours can spoil an otherwise successful painting.

To me, one of the most important requirements is an understanding of colour temperature. All colours can be considered as warm or cool. Red is often regarded as a 'hot' colour, but permanent rose, for example, is a cool blue-red, whereas cadmium red is a warm yellow-red. Blue, on the other hand, could be seen as a cold colour, but it can be a warm ultramarine, or a cool phthalo blue. Similarly, Winsor lemon is a cool yellow while cadmium yellow deep is a warm red-yellow.

In a painting, warm colours (browns, brown-greens, reds and oranges) appear to be close to the viewer, while cool colours (blues, violets and blue-greens) inply distance. So, in the context of a landscape, it makes sense to include cool colours in middle and distant parts of a composition, and warm ones in the foreground.

In order to fully appreciate how colours work, I suggest you paint a colour wheel (see below), on a piece of white canvas board or primed cardboard. If you have not used oils before, it will give you a chance to get used to the feel of them and how they mix. Do not thin the paint, and scoop it off the palette rather than dipping into it. Clean your brush at regular intervals to avoid muddying the colours. Colours that are opposite each other on the

wheel are known as complementary colours – yellow and purple, orange and blue, red and green – and these can also work well in the compositional sense. A painting with a lot of greens, for example, will be enlivened considerably by a touch of red and so on. Another use of complementary colours is to subdue or tone-down vibrant colours. So, if your trees are too green, a touch of red can often subdue the colour enough to make it look more natural.

Painting a colour wheel

Lay out a white and a warm and cool version of the three primary colours on a palette. For this wheel, I used the following colours: titanium white; Winsor lemon, a cool yellow; cadmium yellow deep, a warm yellow; cadmium red, a warm red; permanent rose, a cool red; ultramarine (green shade), a warm blue; and phthalo blue, a cool blue.

Start the basic colour wheel (the inner of the three circles) at about the seven o'clock position with a small block of cool yellow. Then, working clockwise, gradually mix touches of warm yellow to the cool yellow and add more blocks until you have a block of pure warm yellow. Now mix tiny touches of warm red to pure warm yellow and lay in more blocks of colour until you have a block of pure warm red. Cadmium red is quite strong, so be

careful with the mixes. Complete the warm side of the wheel by mixing touches of cool red to the warm one and adding blocks of colour to the wheel until you have a block of pure cool red. Permanent rose is fairly weak so you will need a lot for it to have an effect.

Work round the cool side of the wheel, introducing the warm blue to the cool red, the cool blue to the warm one, then the cool yellow to the cool blue. For this wheel, I mixed my blues, ultramarine (green shade) and phthalo blue with titanium white to create warm and cool mid-blues.

When the basic wheel is complete, the yellows should be opposite the purples, the oranges opposite the blues and the reds opposite the greens. These are the complementary pairs of colours referred to earlier, and they can be mixed to produce the wide range of brownish colours (the spokes of the colour wheel).

In this example, I developed the wheel further to show a range of tints. I lay in an outer band of pure white, keeping it slightly away from the basic colour wheel, then dragged the colours from the basic wheel across half the width of the white. I then dragged these tinted across the remaining width of white to produce paler hues of each colour.

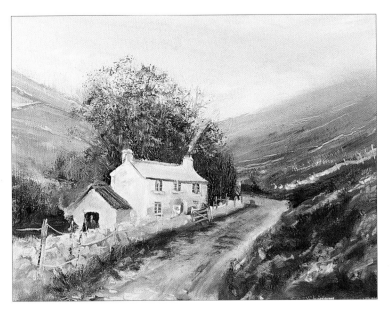

Autumn on Dartmoor
Size: 400 x 300mm (15¾ x 11¾ in)

This atmospheric composition makes good use of complementary colours – the warm orange-browns of the tree and foreground foliage, and the cool hazy blue of the distant hill.

13

Mixing your own greens

It is possible to use a ready-made mid green (say sap green) and modify it with Winsor lemon or Naples yellow to create lighter tones, and ultramarine (green shade) or burnt sienna to make darker ones. Making your own greens, however, should be the aim of every landscape artist. It is not difficult to mix attractive greens, and once you have mastered the technique, you will never be stuck for the correct tone or shade.

For my basic green, I use Winsor lemon – a clean coolish yellow – and ultramarine (green shade), a cooler version of the traditional ultramarine blue. For darker shades, I add more ultramarine (green shade) or burnt sienna. To lighten these greens, I add Naples yellow for warm shades or titanium white for cooler, receding greens.

Try out these mixes or experiment with your own colours. There are two important points to remember: natural looking greens often have a lot of brown or yellow in them, especially those in the foreground; and distant greens are best made paler and bluer.

Sometimes, we are faced with the problem of distant greens that are quite dark. A good way of dealing with this is to make the colour more blue than green, so that they still appear to recede. Phthalo blue is a good blue to use; add a little Winsor lemon to make it greenish and some titanium white to achieve the correct tone. Be careful when using this blue; it is very strong so use it sparingly.

1 – Winsor lemon and ultramarine (green shade)

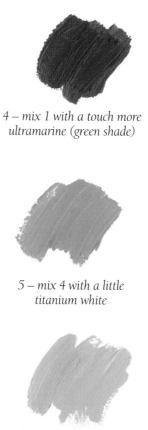

4 – mix 1 with a touch more ultramarine (green shade)

7 – mix 1 with some burnt sienna

2 – mix 1 with a little Naples yellow

5 – mix 4 with a little titanium white

8 – mix 7 with a little Naples yellow

3 – mix 2 with a touch more Naples yellow

6 – mix 5 with a touch more titanium white

9 – mix 8 with a touch more Naples yellow

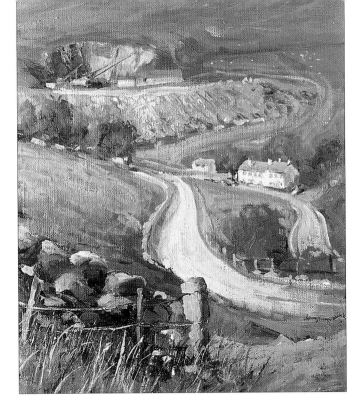

Merrivale Quarry

Size: 240 x 300mm (9½ x 11¾ in)

A moorland setting like this enables me to use a wide variety of warm and cool greens. I painted this image on site, in one session. I chose an orange-tinted board to work on, and allowed some of the colour to show through here and there to unify the painting. Orange or red can work well as a background colour for greens as it tends to soften and modify them.

10 – Winsor lemon and Naples yellow

13 – A lot of Winsor lemon with a little ultramarine (green shade)

16 – Winsor lemon with a tiny amount of phthalo blue

11 – mix 10 with a little titanium white

14 – mix 13 with a little more Winsor lemon and some titanium white

17 – mix 16 with a little titanium white

12 – mix 11 with a touch more titanium white

15 – mix 14 with more touches of Winsor lemon and titanium white

18 – mix 17 with a touch more titanium white

Painting techniques

Oil paint is the most versatile of all painting mediums. It is possible to adopt many techniques and, due to the slow drying time, oils can be superimposed on one another or scraped back to show the original colours. Sponges, rollers, stamps, fingers, and even bicycle tyres and plastic cutlery have been used to produce works of art in oils! Try some of these more traditional methods, then maybe invent some exciting ones of your own.

Wet on wet

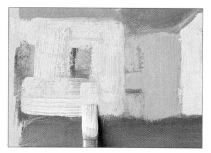

This is the most immediate and simplest technique. Colours are brushed on with little or no dilution and the painting is built up with brush strokes which remain visible.

When working wet on wet, the application of paint is likely to lift off some of the colour already applied. This can result in a muddy colours, especially when putting light on to dark or *vice versa*. To keep colours fresh and clean, get into the habit of wiping the brush with a paper towel or clean rag every few strokes, then recharging it with clean colour.

All the demonstrations in this book were painted wet on wet.

The easiest way to get started is to begin on a tinted canvas or board, allowing some of this background colour to show through here and there, to unify the painting.

Wet on dry

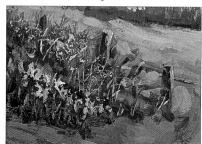

This is a very traditional oil painting technique, where the painting is allowed to dry thoroughly between layers. It is not for the impatient – one to two weeks should be left between stages – although this time can be reduced to a few days by using a fast drying medium.

The one important rule in oils – 'fat over lean' – must be followed to ensure good adhesion between coats of paint. When working on a dry painting (except the primer coat on the board or canvas), any dilution of paint must be made with linseed oil or a medium, not turpentine or white spirit.

Wet on dry is a very good technique for building up intricate, fine detail over a period of time.

Scumbling

Scumbling is a classic, broken-colour technique which creates a lively, textured appearance. It is particularly useful for masses of foliage, clouds, moorland or mountains, rough-textured walls and old buildings. It can be used wet on wet or wet on dry, but do allow the colours underneath to show through here and there. Although it is possible to scumble several colours in one area, it is better to use similar tones or the effect can look clumsy.

Scumbling can be a very useful technique for rescuing a bland area of a painting, where a flat area has become uninteresting – simply mix a colour, similar in tone but slightly different in colour, and apply loosely with a big brush, making sure to leave plenty of gaps between brush strokes. A very satisfying effect can be achieved this way.

Dry brush

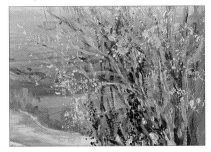

In oils, unlike watercolour, the highlights are applied last, on top of a darker colour. To achieve an effect like sparkling water, or of light rippling on a cornfield, the pale vibrant colour must be dragged across the surface so that the brush stroke breaks up in an interesting, irregular way.

The brush should be held lightly, well back on the handle, with the handle parallel to, and almost touching, the surface. Very little pressure is applied and the paint is literally dragged off the brush. This technique can be wet on wet or wet on dry.

Sgraffito

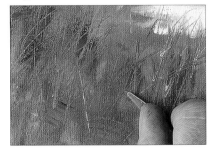

This technique entails scraping back through wet colour to show a different colour underneath. You can use any pointed object: the tip of a painting knife, a wooden skewer or even the sharpened handle of a paint brush.

For most of my paintings, the under-colour is the primed board or canvas, so I choose a primer colour to suit the subject. For best results, the undercolour should be a different tone to the layer being scraped through.

Sgraffito is excellent for detail where clean, crisp lines are required: grasses, hair, fence posts, gates, masts, ropes, stems of flowers and branches.

Impasto

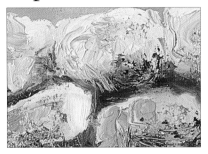

This is a technique which in extreme cases can become almost sculptural. Heavy layers of paint are built up to create a rough, textural surface that adds a further dimension to the painting. Stiff brushes and knives are best used for impasto work, with no attempt at hiding the strokes. A very directional appearance can be achieved with impasto, to imply the slope of a hill, the movement of water, or light through trees. The effect tends to dominate a painting and is best restricted to the foreground or middle distance.

If you want a really heavy, more textured impasto, use an impasto medium to bulk out the paint.

Glazing (see also page 39)

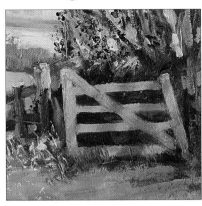

A glaze is a coloured, transparent varnish used to change colours in a painting without losing any of the detail underneath. Always mix colours with a glazing medium, not linseed oil or turpentine. Most glazing mediums dry in a day or two, and it is best to allow the glaze to become completely dry before working subsequent layers, or parts of it could be smudged and the glaze made muddy. The best colours to use are those listed in manufacturers' colour charts as transparent or semi-opaque. Opaque colours will look muddy.

I sometimes use a glaze to add shadows or form, or to modify part of a painting that has not worked. Some artists work almost exclusively in thin glazes, carefully building up the desired effect. A good way of using a glaze is to put a complementary colour on top of one that appears too vibrant or bright – while still allowing some of the bright colour to show through here and there.

Elements of a landscape

When composing a landscape, it always helps to divide the scene into three separate elements – the sky and horizon, the foreground and the middle distance – then consider how best to include other objects such as trees, water, buildings and figures. Analysing an image in this way gives a better idea of where cool and warm colours should be used to achieve depth and distance in the painting.

Skies and distance

The sky is the illumination of a landscape and all the colours and tones we see are affected by it. A painting looks much more believable if a realistic sky shines down upon it.

Look at skies and cloud formations whenever you get the chance. Note the difference between the blue of the sky near the horizon and the colour directly overhead. Note how the clouds are lit from one side and shaded on the other, and that their undersides are darker than their tops. Try to recognise the three main cloud types: stratus, a layer or overcast type cloud; cirrus, wispy streaky clouds; and cumulus, lumpy, heaped clouds. These observations will make you much more confident when painting clouds.

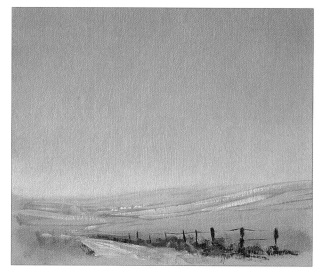

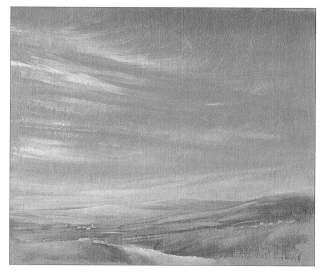

This simple blue sky was painted with three mixed blues; ultramarine (green shade) and a lot of titanium white was used for the top of the sky; ultramarine (green shade) with a tiny touch of phthalo blue and more titanium white (to make it paler) for the middle; and just phthalo blue and titanium white at the bottom. A mix of ultramarine (green shade), titanium white and a touch of Winsor lemon (a pale blue-green) was used to make the distant hills. The colours were then blended together with a clean dry fan brush.

This is a typical cirrus cloud sky. The basic sky was painted in the same way as the simple blue sky left. I brushed on streaks of titanium white, then used diagonal strokes of a clean dry fan brush to create the soft feathery look.

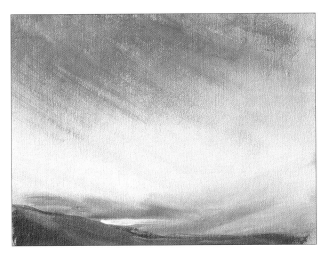

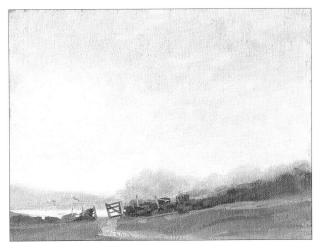

For this overcast sky with light rain, I brushed a darkish purple-grey across the top of the sky, a mid blue fading down to pale blue across the middle and bottom parts, and a grey-blue along the horizon. The fan brush was then used to pull diagonal lines down through the dark to light, almost obliterating the horizon. Rain and drizzle is quite challenging to paint, but do not catch flu!

Here, the sun is obliterated by thin stratus clouds but it shows up as a paler patch of sky. This type of sky can be almost any colour, depending on the time of day – creamy yellow, warm or cool grey, pink, or even pale brown. An overcast sky causes most colours to darken, and shadows are virtually nonexistent. This type of light makes it almost possible to paint a landscape in monochrome.

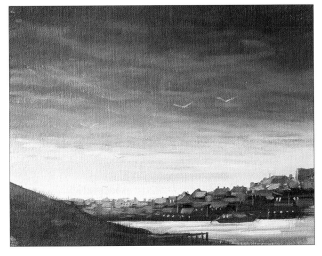

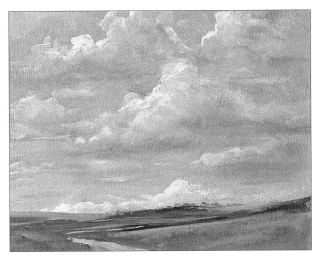

A mix of stratus and cumulus clouds gives a textured, slightly lumpy appearance which, because the sun has just set, is illuminated from below to give warm orange highlights. In this painting, the last of the sun catches the roof tops and cloud colours are reflected in the water; a useful way of getting some warmth in the foreground.

In this fair weather sky, the opaque lumpy cumulus clouds are lit from the left. If there is a lot of cloud cover, it is often easier to block in the simple shapes of the clouds and separate them here and there with patches of blue, rather than trying to paint clouds on a blue sky. The pale grey used for these clouds is titanium white with touches of ultramarine (green shade) and burnt sienna, the purple shadows are a mix of titanium white, ultramarine (green shade) and touches of permanent rose and Naples yellow, while the creamy-white on the sunlit sides is titanium white with a touch of Naples yellow.

If you need a fairly dark horizon, remember to use some blue in it to make it recede. Get the horizon correct tonally and you are well on the way to a good painting.

Foregrounds

Foregrounds can make or break a painting. Often, the tendency is to try and include everything. The problem with this approach, apart from the extra work involved, is that the whole image becomes very busy and the viewer's eye is confused by too much detail. Try this test. Find a spot where you can see into the distance and look at an object a few hundred metres (yards) away. Then, without taking your eye off this object, ask yourself if you can actually make out everything in the foreground. Is every blade of grass pin sharp? Can you see every crack in the pavement? I doubt it. If you want to paint a detailed foreground, I suggest that you make that the focus of your painting and everything else of secondary importance. Do not try to include detailed foregrounds, detailed buildings, figures or trees and detailed distance in one painting. It's too much.

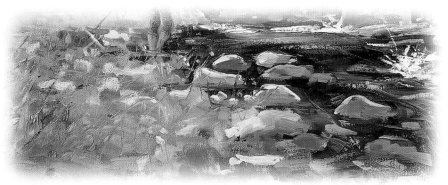

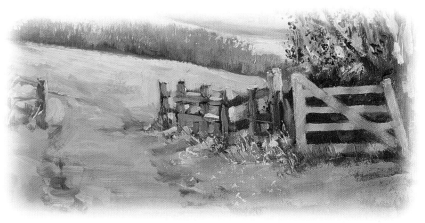

I like to ensure that my foregrounds appear nearer than the rest of the painting in two ways – by using contrasting tones and warm colours. In this detail from the painting on page 47, I deliberately used dark blues for the water to contrast with the warm but pale colour of the rocks. I also used lots of reddish-browns in the grassy area at the left-hand side to make it appear near.

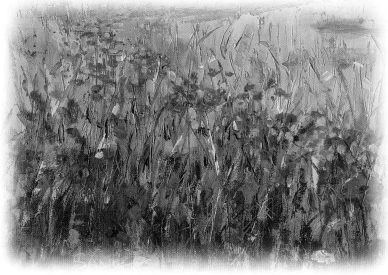

In this foreground detail of the painting on page 39, brownish wheel ruts lead the eye through the open gate into the field and beyond. The gate at the right-hand side has the maximum contrast, and the diagonal shadows also help draw the eye towards the fence and open gate. The grass is implied, rather than painted in detail, and there is an underlying warmth, produced by touches of burnt sienna.

These poppies (the foreground of the painting on the cover) do a wonderful job of creating depth; everything else looks further away when compared to the glowing reds. Notice that only a few are painted with any degree of accuracy; most are implied with a few strokes of the brush, and the distant ones were added using the dry brush technique. I used the sgraffito technique for some of the corn stalks and poppy stems, scraping back to show the base colour beneath, but none is portrayed in crisp detail. I deliberately created a slightly out-of-focus effect, otherwise the image would have been too busy.

Middle distance

The middle distance can contain many features – fields, trees, a river, an isolated building or a village. This part of a picture can be used to lead the eye round the painting – roads, hedges, rows of trees, can all be used to guide the viewer in this way.

The point to remember is that objects in the middle distance have to appear to recede: greens should be pale and blueish, rather than bright or strong; yellow should be pale and cool (lemon yellow is an ideal colour); and browns, reds and oranges should either be very muted (by adding a little pale blue) or not appear at all.

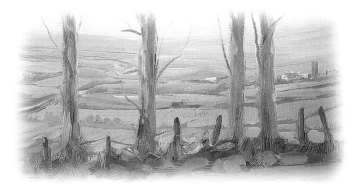

This simple middle distance (a detail from the painting on page 1) leads the eye from tree to tree, adds a touch of perspective with the blue-shadowed hedges and includes its own subject – the cluster of houses and the church tower at the right-hand side. In this type of scene, always remember that to make middle distance objects recede, they should be paler in tone than the foreground elements.

A common mistake when painting distant rivers or roads is to make the horizontal direction of them too wide. In this detail from the painting on page 39, the river runs away from the viewer, then turns left. Because we are looking obliquely, the river almost disappears between its banks after it turns the corner. A nice touch is the hint of masts, applied while the paint was still wet, with the edge of a knife. Notice how the sun is only catching the top of the hill while the bottom is in deep shadow.

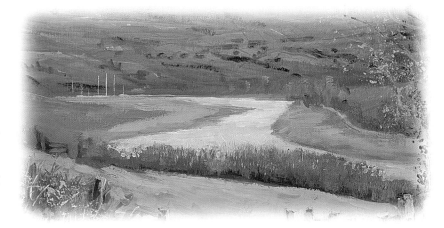

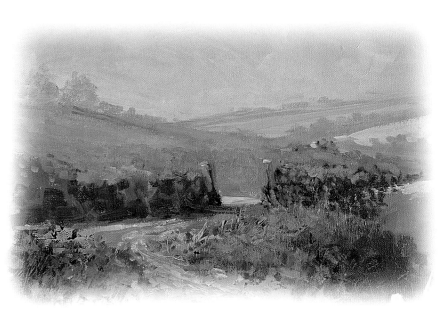

Careful control of tones is necessary to imply distance. In this detail from the painting on page 47, it would have been easy to make the hedge, seen through the broken gate, too dark and lose the illusion of depth. Notice that there are no hard edges to any of the shapes; hard edges and sharp contrast only belong in the foreground.

Trees

The way to tackle trees is to paint the mass of foliage and not the detail. Very rarely do leaf-by-leaf paintings of trees work, and they often look too busy and top heavy. Take time to really look at trees and bushes. Look at them through half-closed eyes and you will see the big masses of foliage, rather than a complicated collections of leaves. Be aware of the direction of the light; notice how the light catches one side more than the other, and how they are darker underneath and near to the trunk.

If when painting a tree it gets near to the top of the canvas, never try to squash it in, simply paint it up and out of the image. If it wants to grow out of the top of your painting – let it!

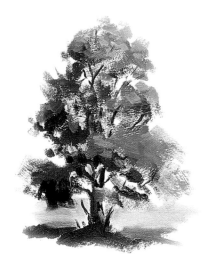

I started this simple tree by painting the foliage with a mid-green allowing plenty of gaps for branches and patches of sky. I painted the dark foliage on the left-hand side of the tree with the same green mixed with a touch of burnt sienna, then worked up the right-hand side and top of the tree with paler tones.

When I was happy with the shapes of the foliage, I painted the branches in the gaps, and added the trunk. Finally, I painted the shadow beneath the tree to help 'ground' it.

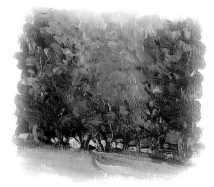

Individual trees in a mass are more easily defined by the use of tonal differences than anything else. Here, the pale tree in the centre looks nearer than the blue-green ones around it. No attempt has been made to blend the brush strokes or apply any detail. The sunlit field behind the trees, painted with pale yellow-green, helps give depth to the composition and accentuates the shapes of the tree trunks.

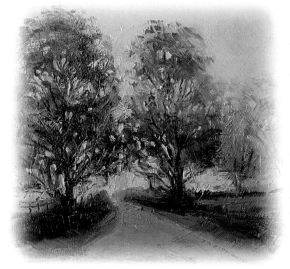

These autumn trees were painted wet on dry over a heavily textured under painting. When dry, a dry brush technique was used to drag a mid-brown colour on to the board, then some paler orange-red touches were applied with a large flat brush. Sgraffito was used to create some branches, while others were painted with a small round brush.

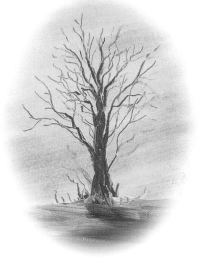

A tree in winter or dead tree can be a real problem, especially wet on wet. Sgraffito (see page 17) is one way of producing the fine lines of the branches, but you must have a fairly dark primer for this to work. Here, the trunk and branches were scraped out of a pale sky to reveal the dark primer colour.

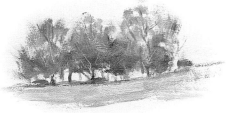

Just a few simple brush strokes were required to paint these trees. The blue tones makes them recede and the lack of detail keeps them there.

Water

The sky plays a big part in determining the colour of water. When water is still, its surface acts as a mirror that reflects everything. When there are ripples on the surface, caused by the wind, fish rising or currents, then the reflections become broken and diffused; colours are still reflected but not much of the shape will be recognisable. Fast flowing water or water cascading over rocks contains lots of air bubbles making the water appear frothy or white.

The direction of brush strokes can imply movement or lack of it. In general, horizontal strokes imply static water, but make them slope one way or another and the eye will 'see' movement in the water.

All the brush strokes in this sketch are horizontal, suggesting a static body of water. The use of dark colours for the reflections implies that the water is quite deep. The shapes of the reflections are quite recognisable, but the outlines are broken here and there to suggest some movement on the surface of the water.

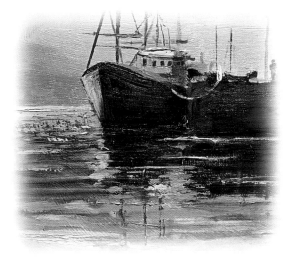

The sky plays a part in the colour of the water, even in the sea. In this evening scene of a boat moored against the harbour wall, the sea and sky are painted with the same colours. Movement is implied by broken shapes on the surface interspersed with white areas caused by small waves. The shadowed sides of the hull and the harbour wall create the dark reflections, but there is still enough light available to allow subtle reflections of the masts, superstructure and the sunlit side of the vessel.

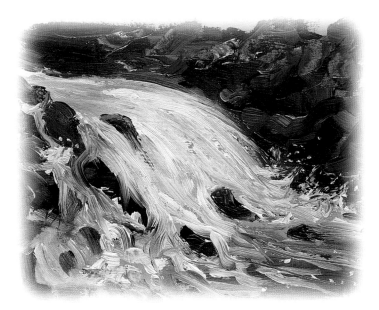

Here, in this sketch of a waterfall, vigorous movement is created by diagonal brush strokes which follow the flow of water around the boulders and down into the pool at the bottom. Reflections in moving water are minimal and broken. Keeping the brushwork loose and dynamic helps impart movement.

Buildings

The inclusion of buildings in a landscape painting gives a human touch, a sense of scale and can often be the focal point. Buildings in the middle or distant ground, need very little in the way of detail and, sometimes, just a couple of brush strokes can imply a cottage, church or barn. If the building is nearer, or is the focal point of the subject, greater accuracy in portrayal is required, especially with regard to how it sits in the landscape. The addition of little details – pathways, gates, garden walls or fences, sheds and extensions – will make a scene look alive and interesting.

When a building is set among trees, it is important to check those parts obscured by branches or tree trunks. A glimpse of a cottage through trees can be very intriguing, especially if complementary colours can be used to contrast with surrounding hues.

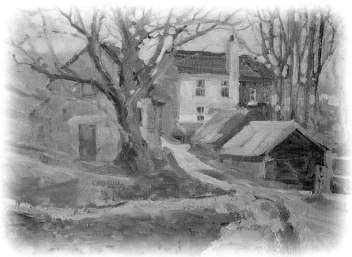

This group of buildings was painted with simple brush strokes. Shadows were used to good effect on the sides of the cottage and sheds. Try to avoid a plain, neutral grey for shadows. I often make a pale grey by adding ultramarine and burnt sienna to titanium white, a touch at a time. For warm greys use more burnt sienna, for cool ones more ultramarine. It is then possible to make a pale cool grey turn purple by adding a tiny touch of permanent rose.

If a building is a creamy off-white, the shadows on it can be a complementary, pale purple-grey colour. If it is brown or orange, blue can be used.

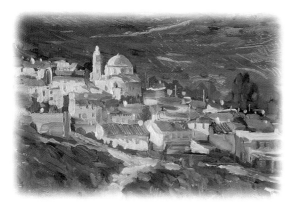

When confronted with a mass of buildings, it is easy to be overwhelmed! A good technique is to avoid all detail, except on one or two buildings. If you squint through half-closed eyes you will see the simplified shape, as a unit. Keep colour changes to a minimum – go for the overall impression. Tone down terracotta roofs with a touch of mid or pale blue, or they dominate the rest of the painting, especially if they are some distance away.

I often use sgraffito to scrape out the hint of windows and doors. This is a very useful method because, after scraping out a shape of a window, if you wish you had not done so, you can put the paint back on again!

This isolated farmstead is glimpsed through the trees, so very little of it is visible. This kind of image must be kept simple, but it requires careful control of tones. Here the tone of the roof is slightly lighter than the background. If I had made it darker, the impact would have been lost. The very dark trees provide a dramatic contrast to the pale colours of the farmhouse and barns. Glimpses of pale colour (made with just a couple of brush strokes) give a hint of more buildings at the right-hand side.

Figures

I find having a figure or two in a painting very useful as they impart a sense of scale. Everyone knows the size of a human being, so, if you include a figure in a landscape, size comparisons within an image are easy. Always plan to include figures before you start painting; a figure added as an afterthought is likely to look just that!

Giving figures something to do is also useful. I have a reference file of people engaged in various activities. Photography helps here; take candid photographs of people going about their business or ask a friend to pose. If someone is prepared to pose, take photographs from several viewpoints.

If your figure drawing is not very good, you have two options. First, you could enlarge or reduce a photograph to an appropriate size on a photocopier (black and white is fine as you only need the shape), then trace the shape on to your board before you start to paint. Yes, it is cheating, but it is the end result that counts! You could also use watercolour or coloured pencils to colour a cut out photocopy and place it on a dry background to see how it looks before actually painting it. The second option is to practise figure drawing! Joining a life class is very good for you artistically and socially.

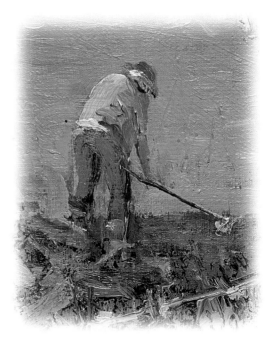

When painting a figure like this, restrict the number of brushstrokes you use. A painting that suddenly gets tight and fiddly in one area will look odd and unbalanced. Decide on the direction of light and mix up a light and dark version of each colour you intend to use. A good flesh tone colour can be made from white and burnt sienna. Practise painting your figure on a separate piece of board, trying to remove any unnecessary brush strokes. Paint the lightest touches last.

Clothing can often be used to good effect to introduce a touch of complementary colour into a painting. This is always worth remembering when you are painting figures; touches of red, in a predominantly green landscape, work very well.

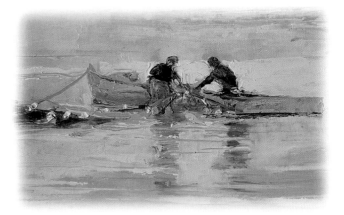

If you want to include figures in your paintings, I suggest that you build up a reference file of people engaged in various activities. Groups of people working together can be tricky if you are not sure what they are up to. I sometimes take notes and file these with the photographs to remind me who was doing what. If figures are some distance away, paint them to scale with their surroundings. Do not be tempted to make them too big.

Cornish Landscape

This typical Cornish scene is built up from an indifferent photograph and a sketch. Because the sketch has more information, it is more useful than the photograph but it helps to have both to refer to. Taking time to make simple watercolour, pencil or pen and ink sketches *in situ* is a very good habit to get into. Neither of the two reference images conveys the real atmosphere of this little valley, with its tin mines and miner's cottages, but careful use of cool colours in the background and warm ones in the foreground, with some scumbled purples here and there, helps give the right impression.

Remember, a photograph is simply a reference image. Never try and copy one too literally – they can usually be improved upon with careful use of colour and tone.

You will need

40 x 30cm (16 x 12in) stretched canvas, primed with a burnt sienna and gesso mix

No 6 round brush, Nos 2 and 10 long flat brushes and a painting knife

Piece of stiff white paper

Paper towel

Colours:
 Ultramarine (green shade)
 Burnt sienna
 Naples yellow
 Winsor lemon
 Permanent rose
 Titanium white

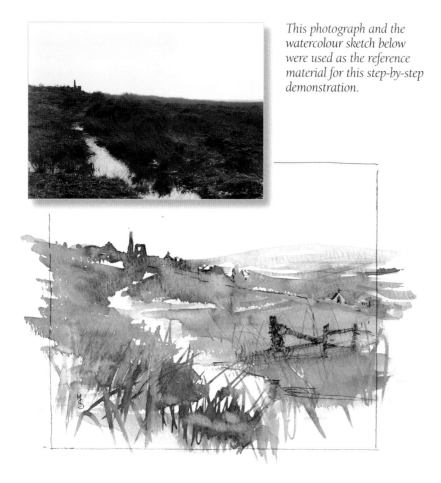

This photograph and the watercolour sketch below were used as the reference material for this step-by-step demonstration.

1. Mix some greys from burnt sienna, ultramarine (green shade) and thinners.

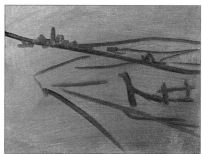

2. Referring to the sketch opposite, use a No 6 round brush to draw in the basic outlines of the composition: the distant hills, the stream, the fence and the fields.

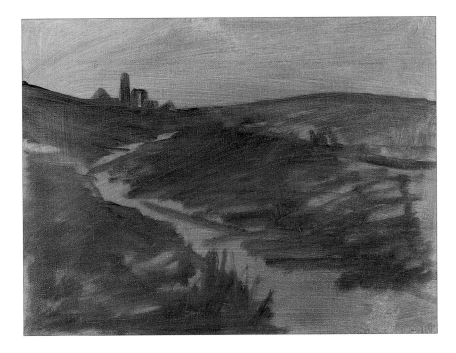

3. Use the tones mixed in step 1 to block in the landscape. Start with blue greys in the background, then introduce warmer tones in the foreground. Work the paint into the canvas to leave just a thin layer of colour. Note that the lines drawn in step 2 gradually disappear. Use a clean paper towel to remove any excess paint.

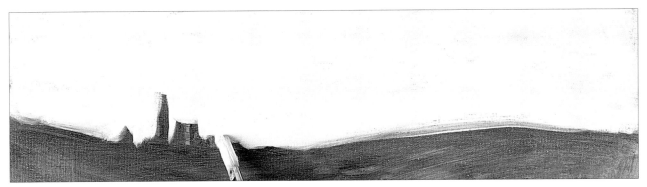

4. Mix titanium white with touches of Naples yellow and the blue grey on the palette, then, working upwards from the horizon, use vigorous strokes of the brush to block in the sky. Allow some of the background colour to show through.

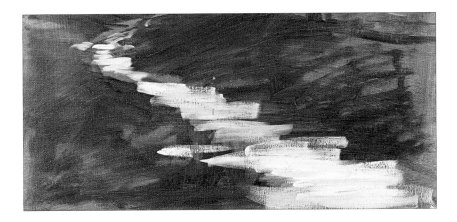

5. Use horizontal strokes of titanium white mixed with touches of the blue grey on the palette to block in the stream. Introduce touches of Naples yellow as you come forward.

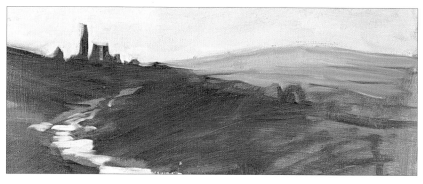

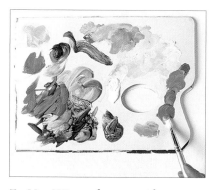

6. Add more of the blue grey to the sky colour, then block in the distant hill, leaving gaps to suggest hedges between fields; soften the skyline edge and add tiny marks to imply trees and buildings.

7. Use Winsor lemon with touches of ultramarine (green shade) and burnt sienna to mix a range of greens.

8. Use the greens to brush in the landscape, adjusting the angle of the brush strokes to indicate the slope of the ground. Allow some of the under colour to show through. Enhance the perspective by adding touches of ultramarine (green shade) to the greens in the distance, and touches of titanium white and burnt sienna to those in the foreground.

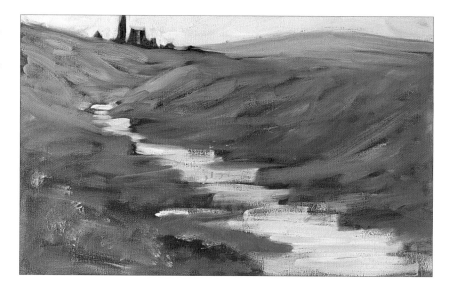

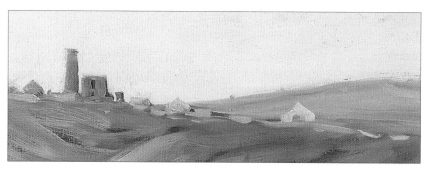

9. Use a mix of burnt sienna and ultramarine (green shade) to re-establish the old fence posts – these will be covered with ivy, so they do not need crisp edges.

10. Use a No 2 brush and ultramarine (green shade) mixed with touches of burnt sienna and titanium white to start defining the shapes of the buildings on the horizon. Keep all edges fairly soft.

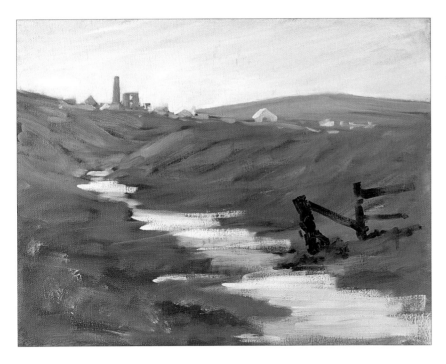

11. Use the No 10 brush and titanium white mixed with touches of Winsor lemon and Naples yellow to strengthen the sky area. Use diagonal brush strokes to indicate wispy clouds. Redefine the outlines of the buildings. Use one stroke of the brush to denote the light roof on the chapel (centre right). Add the suggestion of more buildings at the right-hand side and small highlights on the other buildings. Add some of the sky colour into the water.

12. Use titanium white with a touch of ultramarine (green shade) to adjust the distant hill, then add touches of green from the palette. Use the side of the brush to create distant fields, leaving some of the dark undercolour to indicate the presence of hedges.

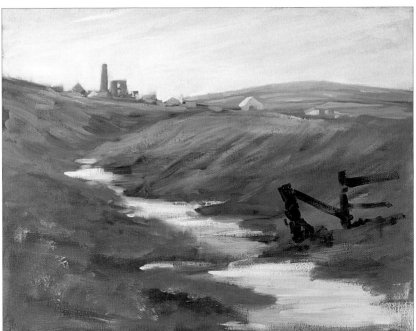

Tip If, when overpainting with light colours, you pick up any of the darker undercolours, wipe the brush with some paper towel.

13. Mix a pale greenish yellow from Winsor lemon, ultramarine (green shade) and Naples yellow with touch of titanium white. Use the dry brush technique (see page 17) to lighten the middle distance slopes on either side of stream. Angle the brush strokes to follow the slope of ground. Add more ultramarine (green shade) to the mix, then develop shadows and darker areas in the middle distance.

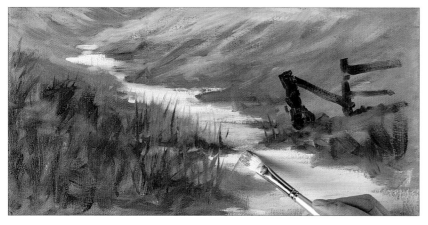

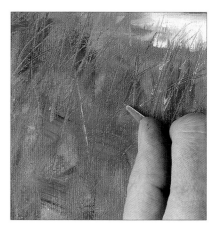

14. Mix ultramarine (green shade) with a touch of burnt sienna, then use the No 10 flat brush to develop the foreground foliage on each side of the stream. Use upward flicks of the brush to suggest clumps of grass.

15. Use the tip of a painting knife to scratch through to the primer coat to indicate fine grasses.

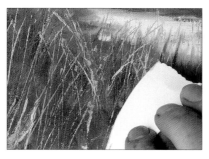

16. Mix Winsor lemon, Naples yellow and burnt sienna roughly with a palette knife. Pick up some of these colours on the straight edge of a piece of stiff paper...

17. ...then apply the paint to the canvas to create blades of grass in these colours. Make straight and curved marks.

18. Mix a dark green from Winsor lemon, ultramarine (green shade) and burnt sienna, then use the handle of a brush to stipple ivy on the fence post. Add titanium white for paler greens. Scratch out a few stems with a painting knife.

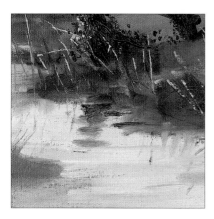

19. Use the greens from the palette to add reflections of the posts and grasses. Drag fine lines of titanium white horizontally through the reflection.

20. Use the painting knife to scratch out a cross on top of the chapel, and to develop detail on the left-hand wall and the door.

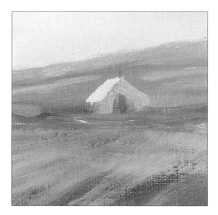

21. Mix a violet (permanent rose with touch of ultramarine), then use the No 2 brush to add shadows on the buildings. Scumble random brush strokes of this colour on the middle distant hills to denote patches of heather.

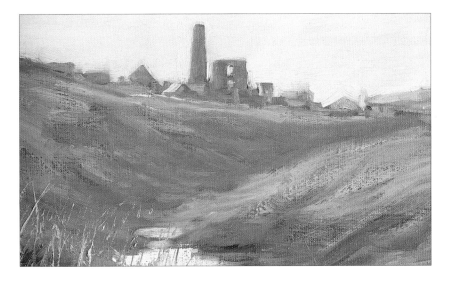

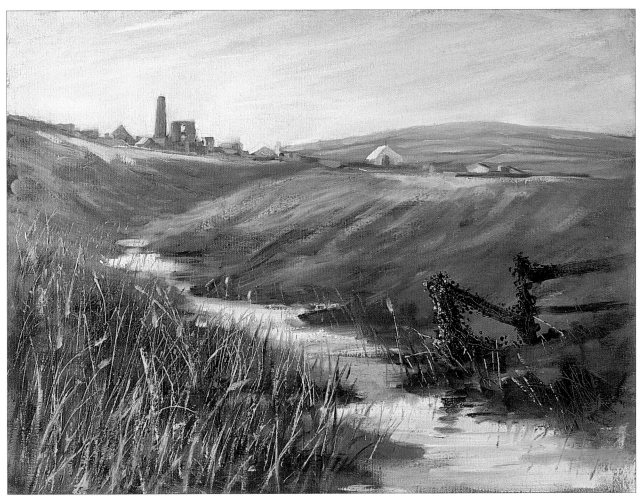

The finished painting. Having stood back to look at the painting after step 21 I decided to make a few adjustments: I added some pale green to the top of the middle distance field and in the far distance; and I muted the colours of the hedgerows with touches of a mid-blue.

Quiet River

The tonal sketch of this peaceful village scene, was done without colour notes or indication of time of day. By choosing pale, warm colours for the buildings, and purple and blue shadows, I have created an evening setting for this demonstration.

I felt that the boat, as portrayed in the tonal sketch, was too horizontal and made the composition rather static, so I decided to change it. I found a photograph of a similar boat in my reference collection, and made a pencil study of it by the side of the original tonal sketch in order to establish the shadows. I also sketched a small outline of the revised composition. As I developed the painting I decided the oars were a distraction, so I left them out.

You will need

30cm (12in) square of 3mm (¹/₈in) cardboard, primed with gesso mixed with a little cadmium red acrylic paint

Nos 2, 6, 10 and 12 long flat brush

Colours:
Ultramarine (green shade)
Permanent rose
Cadmium red
Winsor lemon
Naples yellow
Titanium white
Burnt sienna

This photograph and the sketches below were used as the reference material for this step-by-step demonstration.

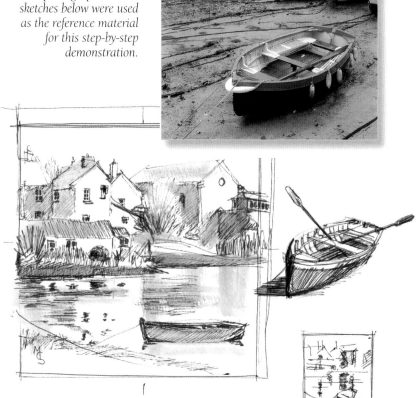

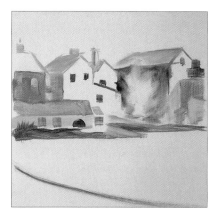

1. Mix shades of purple from ultramarine (green shade), permanent rose and tiny touches of Naples yellow. Thin the colours, then, referring to page 26 and the sketch opposite, use the No 10 brush to draw in the outlines. When you are happy with the composition, use the purples to block in the dark windows and shadowed areas, creating a tonal range that will be maintained through to the finished painting.

2. Mix titanium white with touches of permanent rose and Winsor lemon, then block in the base layer of the sky. Work the brush vigorously to create a thin layer of colours. In this scene, I wanted to achieve the warm glow of a summer evening, so the sky required hints of yellow and violet.

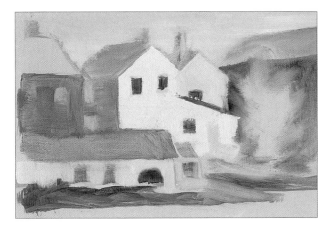

3. Use titanium white with a touch of Naples yellow to block in the front of the middle cottage (notice that I left space for another window to be added later). Add touches of ultramarine (green shade) to the mix and block in the next door cottage and the foreground building.

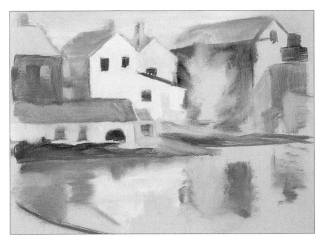

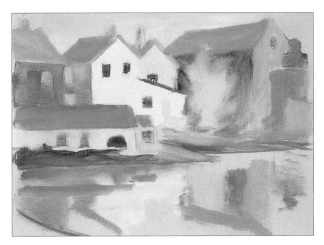

4. Use the same colours to block in the reflections, remembering that they must align vertically with the objects being reflected. Use the existing greys on the palette to add reflections of the dark sides of the buildings. Use a dry brush to soften and merge the edges of all reflections.

5. Mix a pale orange (Naples yellow and cadmium red), then block in the front faces of the right-hand buildings and their reflections. Add a touch of burnt sienna and block in the roofs of the foreground building, the middle cottage, and their reflections. Add touches of titanium white, then block in the roofs of the other buildings.

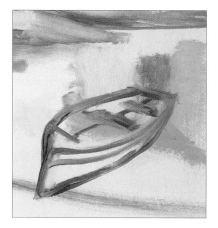

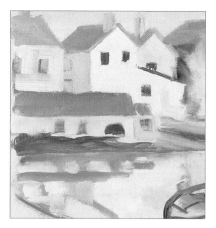

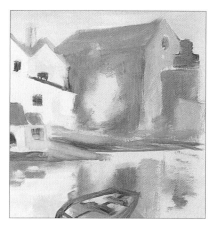

6. Use a thin mix of burnt sienna and ultramarine (green shade) to draw in the outlines of the boat.

7. Weaken the purples on the palette with titanium white, then block in the side of the middle cottage. Add more white and some Naples yellow, then block in the fronts of the left-hand and foreground buildings. Add these colours to the reflections.

8. Mix burnt sienna and Naples yellow with a touch of ultramarine (green shade), then overpaint the purples on the side of the large building, leaving some of the undercolour showing. Scrub some of this green into the reflections.

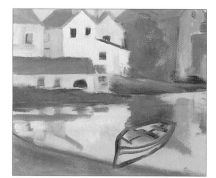

10. Mix a pale orange (cadmium red and Winsor lemon), then use loose irregular brush strokes to develop the sky. Start from the left-hand side, adding touches of titanium white as you work across to the right-hand side. Allow some of the undercolour to show through, and take the colour across the chimneys which will be reinstated later.

9. Mix dark greens from Winsor lemon, ultramarine (green shade) and burnt sienna, then block in the foliage. Use the brush strokes to show the direction of growth. Add more Winsor lemon to work the mid tones (detail and lights and darks will come later). Use a slightly darker tone (more burnt sienna and ultramarine (green shade) and horizontal strokes for the reflections. The reflection of the tree gives a good dark behind the boat. Add touch of titanium white for the foreground.

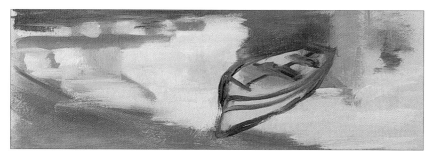

11. Use slightly paler tones for the sky reflection.

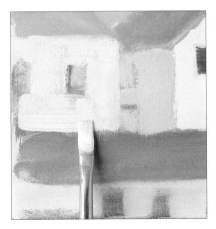

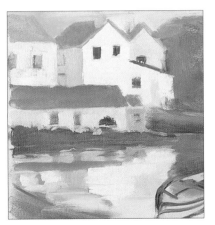

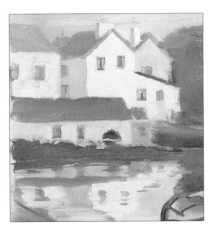

12. Mix Winsor lemon and titanium white, then use the No 6 brush to overpaint the front of the left-hand cottage. Use short strokes to build up a rough stone texture on the wall. Again allow undercolours to show through.

13. Add more titanium white, then paint the front of the middle cottage. Add burnt sienna to make a slightly darker mix to paint the foreground building. Use all these tones to add reflections. Overlap colours to imply ripples on the surface of the water.

14. Use paler tones of the yellows to redefine the chimneys. Mix purple-greys from ultramarine (green shade), Naples yellow and permanent rose, then use the edge of the No 2 brush to adjust the windows and the shadowed side of the chimneys, and to add a distant roof and chimney. Use these tones to paint the reflections.

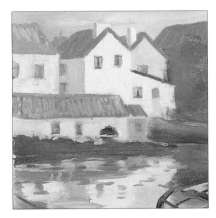

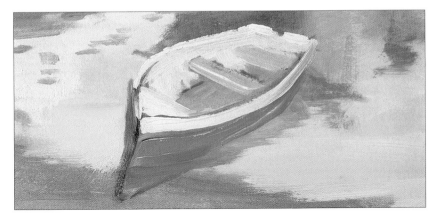

15. Use a mix of burnt sienna, Naples yellow, and a touch of cadmium red to adjust the roofs, angling the brush strokes to follow their slopes. Use short strokes of paler colours to suggest roof tiles. Again add touches of these colours in the reflections.

16. Use ultramarine (green shade) with a touch of permanent rose to block in the side of the boat. Use a weaker tone (add a touch of titanium white) for its reflection in the water, and a deeper tone (more blue) for the shadowed side. Use Winsor lemon with tiny touches of cadmium red and titanium white to block in the insides of the boat; add burnt sienna to the mix and paint the bottom, and cadmium red and more white for the seats. Paint the gunwales and foredeck with titanium white mixed with just a hint of Winsor lemon.

Tip Turn the painting upside down to work the nearside curves of the boat.

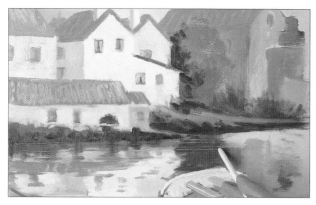

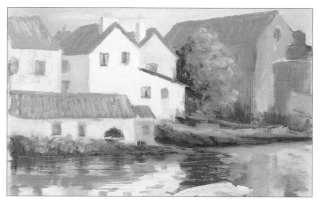

17. Mix a dark green from ultramarine (green shade), Winsor lemon and burnt sienna, then use the No 2 brush and short, upwards strokes to paint the shadowed parts of the tree and the foliage on the far bank, and to define the edges of the buildings and the river. Pull some of the darks down into the water, then use the handle of the brush to make horizontal strokes through these reflections.

18. Mix a pale green from ultramarine (green shade), Winsor lemon and touches of Naples yellow, then work up the highlights on the tree and foliage. Again introduce these colours into the reflections. Use the handle of the brush to scratch out the indication of a few branches and part of the tree trunk.

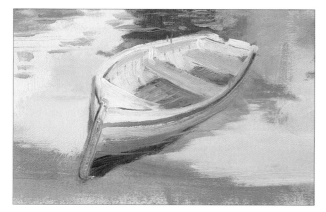

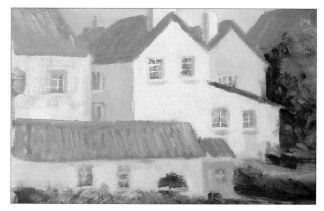

19. Having stood back to look at the painting, I decided to widen the boat slightly. Working upside down, I redefined the gunwales, foredeck and seats, then added shadows in the bottom of the boat. I used the brush handle and the sgrafitto technique to define the planking and other edges and shapes inside of the boat. I completed the detail and highlights with an off-white mix of titanium white and Naples yellow.

20. Referring to page 30, use a small piece of paper and an off-white (titanium white with touch of Naples yellow) to define the window glazing bars. Mix a pale grey from Naples yellow, ultramarine (green shade), burnt sienna, titanium white, then use the edge of the No 2 flat brush create the window recesses and the shadows under the window sills.

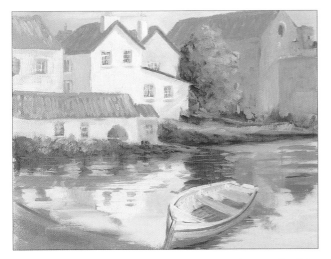

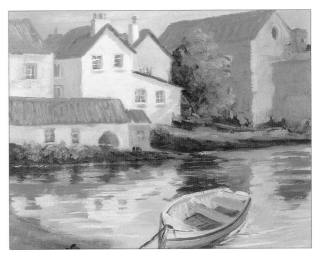

21. Mix a purple-grey from ultramarine (green shade), permanent rose, Naples yellow and titanium white. Scumble this on the side wall of the right-hand building, then add a few holes in the adjacent tree and adjust the shape of the window. Add a touch more white, then paint cast shadows under the eaves of the cottages. Use the greys on the palette to add detail to the shapes at the right-hand side and the reflections.

22. Having stood back to view the composition I was not happy with the right-hand side so I decided amend it. I overpainted the cast shadow on the large building and made its end wall slightly wider. This created a much better reflection to contrast with the stern of the boat. I also used titanium white with hint of grey from the palette to create ripples to the left and right of the boat.

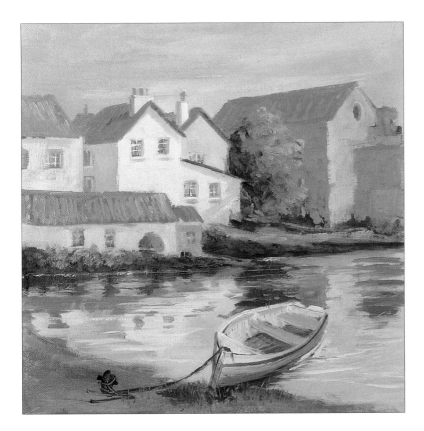

The finished painting. To complete the painting, I modified the foreground grasses to include the shadow of the boat and added a mooring rope. I also modified the reflections of the large building at the right-hand side, then dry brushed a pale mix of Winsor lemon and titanium through the reflections.

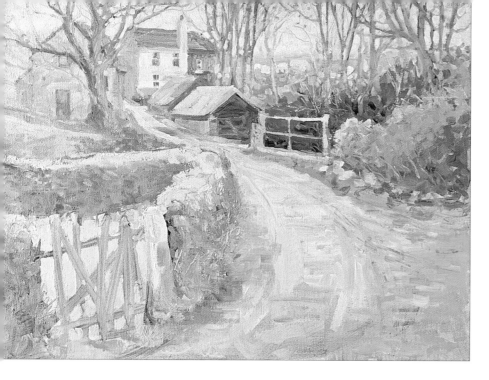

A Corner of Peter Tavy
Size 400 x 300mm (15¾ x 11¾in)

Peter Tavy is a delightful village on the edge of Dartmoor, where I lived in my teens. This image was painted on an orange-buff primer colour, which shows through here and there and is balanced by the blues in the shadows. Paint was scumbled on in quite a loose way, giving a soft-focus effect.

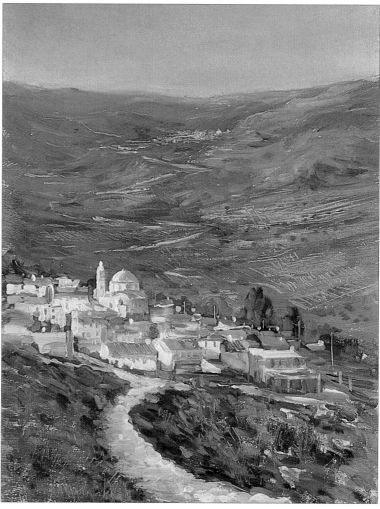

A Cypriot Evening
Size 200 x 270mm (7¾ x 10½in)

I caught sight of this little village, set against a backdrop of dark hills, as we were coming down from the mountains at dusk. I took several photographs as reference, but I also made a couple of sketches, in case the quality of photographs was poor in the evening light. As soon as we returned home, while the memory was still fresh in my mind, I sat down and painted this picture.

Tamar Valley

Size 250 x 190mm (9¾ x 7½in)

This image evokes a sense of place for me: it is a view I know very well. I particularly enjoyed painting the spring leaves, with a dry brush technique and the shadows falling across the gate; glazed on when the paint was dry.

The tiny daffodils were applied with the tip of a small painting knife. The wheel ruts draw the eye in and across the field towards the distant gate.

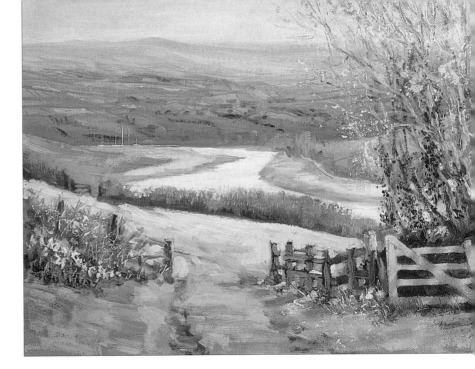

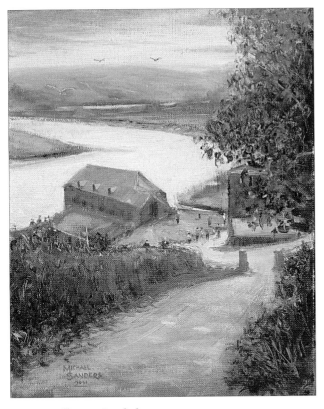

Tamar Valley at Cotehele

Size 245 x 305mm (9½ x 12in)

The glazing technique (see page 17) can be used to change the mood of a painting completely without losing the underlying structure. These images show the painting before and after it was glazed with evening hues. I used a glazing medium, tinted with permanent rose and a hint of Winsor lemon, to cover the top of the painting, then used a clean paper towel to lift out highlights in the sky and river. I added touches of ultramarine (green shade) to the mix, then glazed cast shadows in front of the building and across the road. Finally, I used the tip of a painting knife to redefine the white bird at the left-hand side.

39

St Enodoc Church

I used the reference photograph and the 'golden section rule' to develop this simple outline composition. The golden section rule suggests dividing the painting area into thirds, both horizontally and vertically, and placing the focal point on one of the intersections. Here, the church is the focal point and I have placed it one-third in from the right and one-third down from the top. Note that the horizon also lies one-third down.

Having decided on the basic structure of the composition, I developed the more detailed tonal sketch which I then used as the main reference for this step-by-step demonstration.

You will need

40 x 30cm (16 x 12in) piece of
3mm ($\frac{1}{8}$in) cardboard,
primed with gesso mixed with
a blue-green acrylic paint

Nos 2, 6, and 10 long
flat brushes, a fan blender and
a painting knife

Colours:
Ultramarine (green shade)
Phthalo blue
Permanent rose
Winsor lemon
Naples yellow
Cadmium yellow deep
Titanium white
Burnt sienna

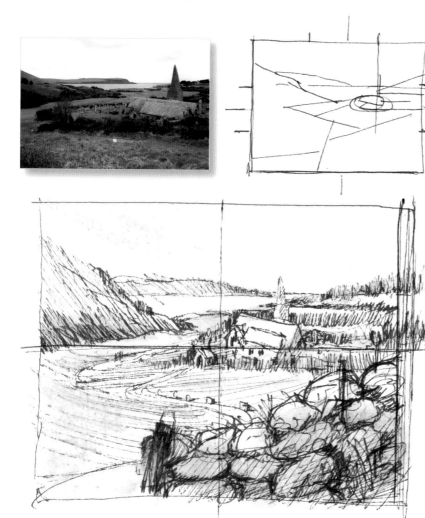

1. Use the No 6 round brush and a thin mix of burnt sienna and ultramarine (green shade), to transfer the grid on to the painting board. Then, working one corner at a time, start to draw in the elements of the landscape.

The completed drawing. The dry-stone wall is suggested by some irregular-shaped stones, and the diagonal line of its top edge adds drama to the scene. The fence post, another diagonal, leans into the composition and draws the eye to the path leading to the church. The path, which gets wider as it goes round corners, enhances the perspective and 'tells' the eye that it is going downhill. Note how the angles of all of the other elements in the composition tend to draw the eye towards the focal point. Notice that I used some paper towel to wipe off the grid lines in the sky.

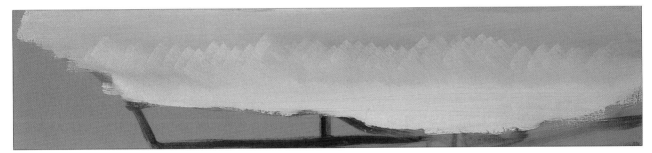

2. Use the No 10 brush and a mix of titanium white and ultramarine (green shade) to block in the top part of the sky. Use a mix of titanium white and a tiny touch of phthalo blue to block in the bottom part.

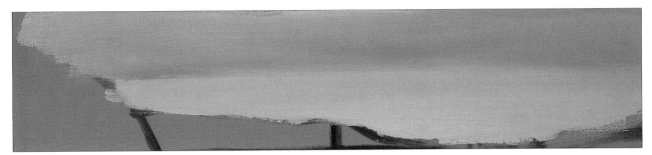

3. Wiping it clean regularly to remove excess paint, use a dry brush to make a series of diagonal strokes between the two blues in the sky. Here I worked the strokes downwards from left to right.

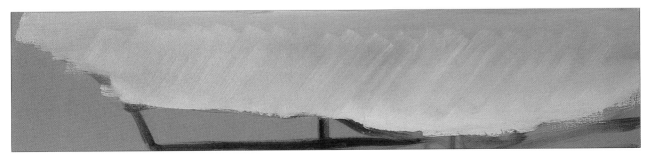

4. Still using a clean dry brush, make another series of strokes, longer than the first set and in the opposite direction.

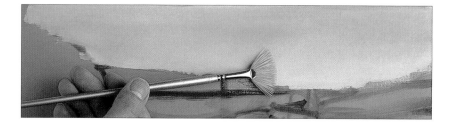

5. Finally, use a clean dry fan brush and long gentle horizontal strokes, worked backwards and forwards across the sky, to blend the colours together.

6. Block in the sea using titanium white mixed with phthalo blue and Winsor lemon. Add more white as you work downwards from the horizon. Add almost pure white streaks under the distant headland.

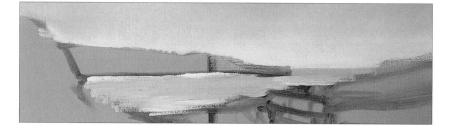

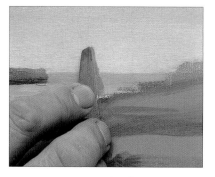

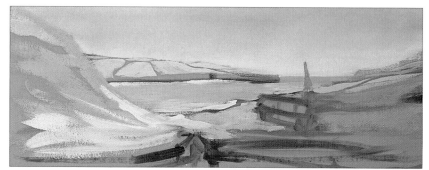

7. Use a painting knife to scratch out the spire of the church. It really does lean at a crazy angle!

8. Mix a range of pale greens from Winsor lemon, ultramarine (green shade), burnt sienna and lots of titanium white, then, using sideways brush strokes, block in the fields on the distant headland, leaving some of the undercolour as hedges. Use warmer greens to paint the fields on the right-hand side. Use a mix of Naples yellow, burnt sienna and a tiny touch of green from the palette to block in the sand dunes at the left-hand side. Using broad free brush strokes, work a mix of titanium white and Winsor lemon into the bottom area of the dunes.

9. Block in the path with a mix of burnt sienna and Naples yellow, adding some of the pale blue sky colour in the distance. Work some of this colour into the sand dunes. Use mixes of ultramarine, Winsor lemon and Naples yellow to block in the rough ground at the left-hand side and the field in front of the church, working the brush strokes to indicate the slope of the land. Warm the green with burnt sienna as you come forward. Add patches of the warm greens between the rocks in the foreground.

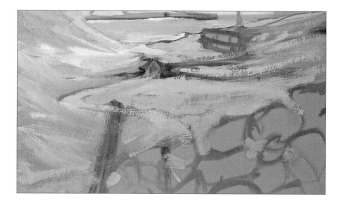

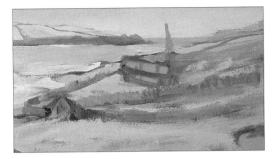

10. Mix a browny-green from ultramarine (green shade), Winsor lemon and burnt sienna, then, using upward brush strokes, define the hedge in front of the church, then block in the small fields behind the church. Add more ultramarine (green shade), then define the wall around the churchyard. Use a mix of ultramarine (green shade) and Naples yellow to define the cliffs of the distant headland, adding some detail at the right-hand end to help lead the eye to the focal point.

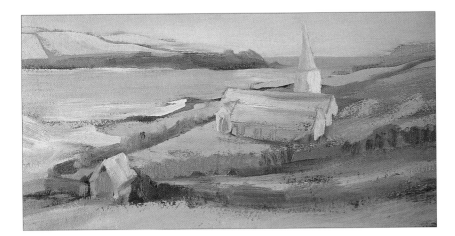

11. Use the No 2 brush and mixes of burnt sienna, Naples yellow and titanium white to paint the church (the source of light is from the top right-hand corner). Add a touch more ultramarine (green shade) for the shadows and for the indications of windows. Use the brush handle to scrape back to the undercolour to redefine the edges of walls and roofs. Paint the lych gate with similar colours.

12. Block in the rocks with a purple-blue mix of ultramarine (green shade), permanent rose and a tiny touch of Naples yellow.

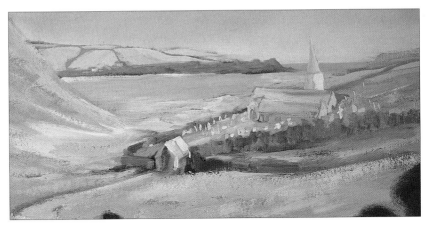

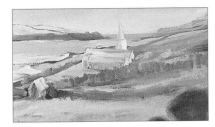

13. Use mixes of burnt sienna, lemon yellow, Naples yellow and titanium white to adjust the hedge in front of the church.

14. Mix a pale purple-grey from ultramarine (green shade), permanent rose and Naples yellow, then add detail to the cliffs on the distant headland leaving some darks as shadows. Use the sky blue to indicate a few buildings. Adjust the ground around the church to define the hollow in which it sits. Modify the sand dunes around the church to reduce tonal differences. Use titanium white with a touch of burnt sienna to add the gravestones. Mix ultramarine (green shade) and Winsor lemon with lots of Naples yellow, then dry brush this across the ground in front of the lych gate and hedge. Use titanium white with a touch of a pale grey mix to add highlights in the graveyard and on the lych gate.

15. Mix a range of warm and cool greys from titanium white, burnt sienna and ultramarine (green shade), then, block in the rocks with thick, textured layers of paint, allowing the undercolour to create areas of shadow. Paint the light side of the old fence post.

16. Use darker tones of the same mixes and a palette knife to develop heavy textures to the rocks. Scrape back some of the colour to create cracks and fissures in the rocks.

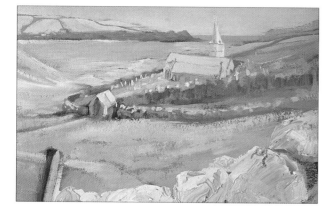

17. Use the greys on the palette to develop the dry stone wall around the church, allowing some of the dark undercolour to show through as shadows. Add a touch of burnt sienna to the grey mix, then lighten the path behind the top of the fence post.

Having finished the rocks, I decided to change the roof of the church to a pale blue grey. I also adjusted the tones on the spire, then used the pointed handle of a small brush to scrape out architectural detail on the church.

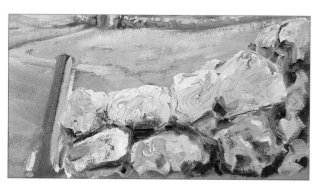 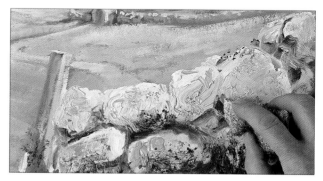

18. Mix a brown-grey from burnt sienna and ultramarine (green shade), then work up the rock shapes with very loose brush strokes. Vary the tone, using the darkest tones at the bottom. Add a touch of titanium white, then paint the shadowed part of the post. Add a small rock at the bottom of the post.

19. Use the greys on the palette to add texture and fine detail to the post. Mix a dark green from ultramarine (green shade) and burnt sienna, and a pale yellow from cadmium yellow deep and titanium white. Use a coarse sponge to dab both colours randomly over the rocks to suggest moss and lichens.

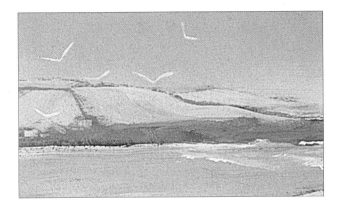

20. Add the finishing touches. Referring to page 30, fold a small piece of paper into a V-shape, dip the folded edge of the paper into titanium white, then add a few seagulls. Reduce the size of the V-shape for more distant birds. Add a few breakers below the cliffs, and use a dry brush to create a few waves rolling into the bay.

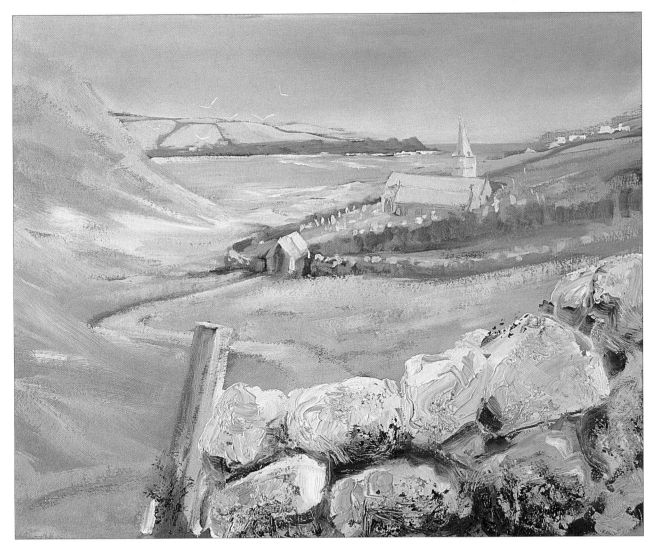

The finished painting

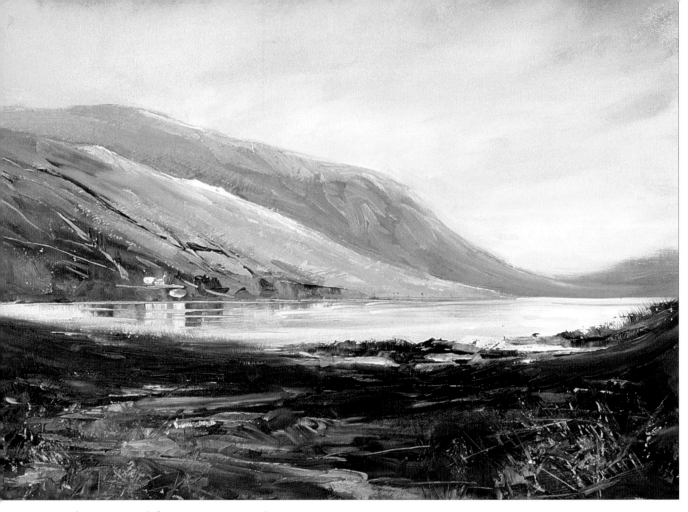

A Lake at Sunset (after Barry Herniman)
Size: 480 x 345mm (19 x 13¾in)

I was at an art materials exhibition watching one of the other artists painting this scene in watercolour. It was a demonstration of clouds and reflections, and I liked the composition so much that I asked if I could use it for an oil painting. This is the finished painting, and I am very pleased with it. Thanks, Barry!

Cornish Sunset
Size: 465 x 500mm (18¼ x 19¾in)

I was very pleased with the way this painting turned out. I know it is bad farming practice, but I always like to paint gates in the open position, not closed.

I painted the warm pale colours of the sky on a board primed with dark grey gesso, softened them with a fan blender, then added the distant purple-grey. I established the tree using a painting knife to scrape back to the dark primer for the trunk and large branches, then a cocktail stick for the finer branches. The ivy was applied in green, spotting the paint on with the handle of a paint brush (see page 30). The buildings were applied simply – just enough to balance the trees.

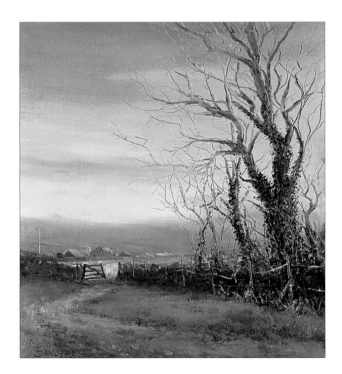

46

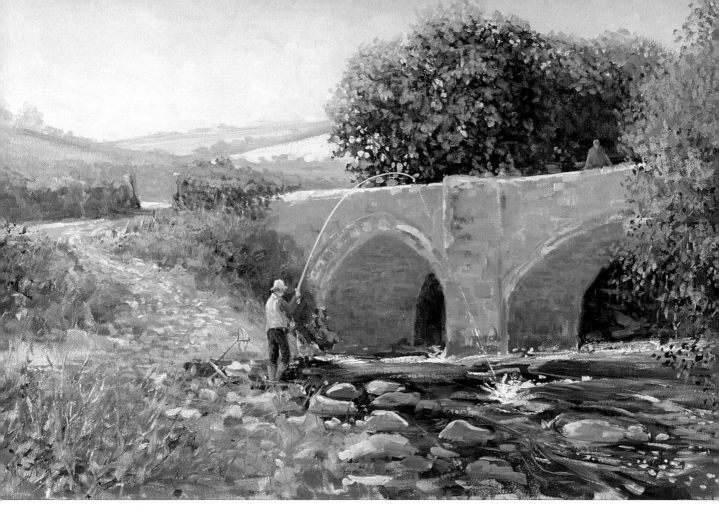

Fishing at Harford Bridge
Size: 750 x 500mm (29½ x 19¾in)

I have always been intrigued by water; how it can go from bright to dark in a few yards or a few seconds, then back to bright again. This bridge over the Tavy, in Devon, is a lovely structure and the river there is very changeable. Quiet, almost serene one minute, then deep and moody. I liked the inky darkness of the water and the pale boulders tumbling down the overgrown bank.

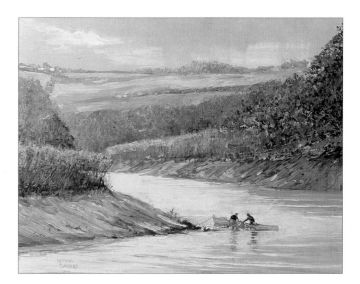

Salmon Fishing
Size: 540 x 420mm (21¼ x 16½in)

Salmon come up the river to spawn and, at high or low water, the fishermen row a wide loop with one end of their net tethered to the bank. This is a timeless image; it could have been painted at almost any period in history, except that it was produced from photographic references!

Index

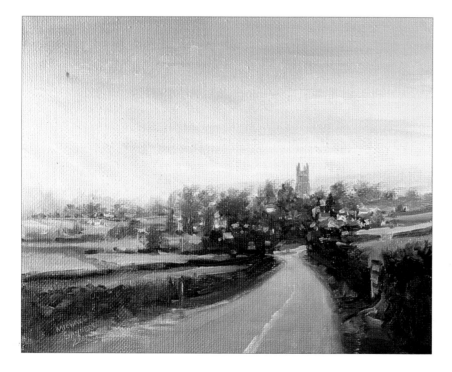

St Mellion in the Rain
Size 300 x 240mm (11¾ x 9½in)

I enjoy the challenge of capturing the atmosphere of a rainy day. Overcast skies have the effect of reducing colours almost to monochrome, and I find the tonal accuracy required can be quite demanding.

When it works, as this image does, it is well worth the effort!